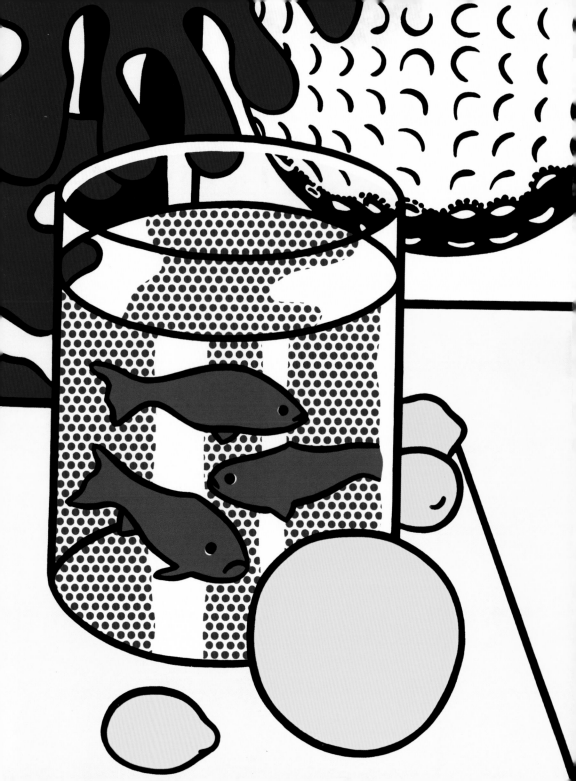

Roy Lichtenstein

Nathan Dunne

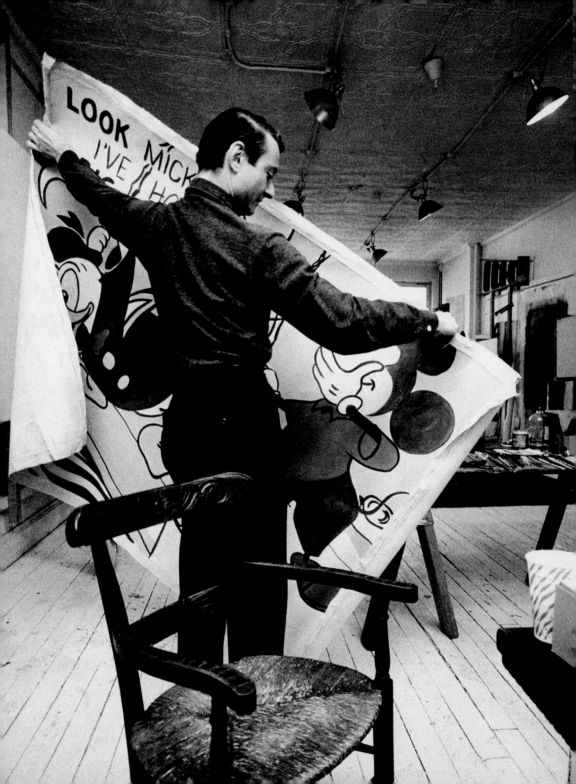

1. Photograph by
Ken Heyman of Roy
Lichtenstein with *Look
Mickey* 1961, in his studio
at 36 West 26th Street,
New York, 1964

Cut copy

The charge levelled at Roy Lichtenstein in the *Life* magazine article,
'Is He the Worst Artist in the US?' (1964), was that he was no more
than a copyist, 'that his paintings of blown-up comic strips, cheap
ads and reproductions are tedious copies of the banal'.[1] His work of
the 1960s was so shocking, in terms of its apparent plagiarism and
naivety, that Lichtenstein quickly became a central figure of American
pop art. Lawrence Alloway has written that a 'broad definition of
Pop art as art about signs seems more useful than the narrow one
of art that uses commercial subject matter'.[2] While the comic-book
paintings remain the most notable of his legacy, they are but a small
number of works in an oeuvre that spanned fifty years.

To understand Lichtenstein's significance, one has to observe the
material complexities of his production. While attention to colour
was an early occupation, Lichtenstein was ultimately obsessed with
form. Despite the starkness of many works, he created a distinctive
iconography based on connections between mass culture and the
history of art. Rather than being empty duplicates of the original
sources, in sampling mustard on bread (fig.29) and Mondrian grids
(fig.35), his work forged a radical ambiguity in which prosaic objects
and iconic artworks were reborn. 'I really don't think that art can be
gross and over-simplified and remain art,' said Lichtenstein in an
interview with John Coplans in 1972, 'I mean, it must have some
subtleties, and it must yield to aesthetic unity, otherwise it's not art'.[3]

Drawing by seeing

Roy Fox Lichtenstein was born on 27 October 1923, at the
Flower Hospital in New York City. His father, Milton, was a real-
estate broker who specialised in managing garages and parking
structures. Although there was no obvious artistic precedent in
terms of the visual arts, his mother Beatrice was a gifted amateur

pianist. Lichtenstein's fascination with jazz, which began during secondary school at the Franklin School for Boys, where he played piano, clarinet and flute in a small band, was born of his mother's influence. He also sought out live jazz concerts at Staples on 57th Street, Manhattan, and the Apollo Theater in Harlem. Coinciding with this embrace of jazz, Lichtenstein enrolled in Saturday morning watercolour classes at Parsons School of Design, where he painted still lifes and flower arrangements. These classes encouraged him to paint figurative watercolours of Belgrade Lakes in Maine, where he spent two summers.

After graduating from secondary school he attended Reginald Marsh's painting class at the Art Students League in New York, where he studied life drawing and Renaissance techniques, such as glazing and underpainting. Marsh espoused a view of art that rejected the European avant-garde art of futurism and cubism, and instead promoted a sentimental realist tradition of depicting American culture: Coney Island in the sun, bourgeois women at the opera, towering cityscapes. Initial attempts by Lichtenstein to assimilate Marsh's approach to art, with sketches of bright beaches and boxing matches while at the Art Students League, gave way to a frustration at his teacher's anti-European reflex. He had been captivated by Pablo Picasso since the age of fourteen, after purchasing his first art book, Thomas Craven's *Modern Art: The Men, the Movements, the Meaning* (1934), in which he encountered a reproduction of *Girl Before a Mirror* 1932. *Guernica* 1937 also made a strong impact on Lichtenstein, when it was shown at The Museum of Modern Art in 1939 to raise funds for refugees of the Spanish Civil War. Admiration for Picasso, whose work would have an impact on Lichtenstein's later paintings, particularly seen in *Femme au Chapeau* 1962 (fig.26) and *Frolic* 1977 (fig.55), was at odds with Marsh's conservative realism.

In September 1940, with the encouragement of his parents, Lichtenstein left the Art Students League and enrolled in the School of Fine Arts at Ohio State University, one of the few institutions to offer studio degree courses. Here he encountered Hoyt Leon Sherman, an influential teacher who taught a class in drawing based on psychological optics. (Lichtenstein later declared that 'The ideas of Professor Hoyt Sherman on perception were my earliest important influence'.)[4] Students would sit in a pitch-black room as

objects and images were flashed onto the wall in quick succession using a tachistoscope (fig.2). The task, outlined in Sherman's book *Drawing by Seeing* (1947), was to draw what had been seen during the brief flash. The flashed objects and images were, initially, easily discernible. However, as the semester progressed, Sherman made the arrangements more complex. He set up three projection screens to vary the depth and thus fragment the image-group.[5] Discussing the influence of Sherman's class, Lichtenstein noted: 'You'd get a very strong afterimage, a total impression, and then you'd draw it in the dark – the point being that you'd have to sense where the parts were in relation to the whole.'[6]

Americana and abstract expressionism

Between 1943 and 1945, during the Second World War, Lichtenstein undertook active service in the US Army, and was deployed to France, Belgium and Germany. During infantry training at Camp Shelby, Mississippi, in 1944, he enlarged cartoons by William H. Mauldin for *Stars and Stripes*, the Army newspaper, an early indication of the process he would explore in the 1960s. After being discharged from duty he returned to Ohio State University, completed his BFA degree under the GI Bill, and began work there as a teacher in the School of

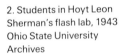

2. Students in Hoyt Leon Sherman's flash lab, 1943 Ohio State University Archives

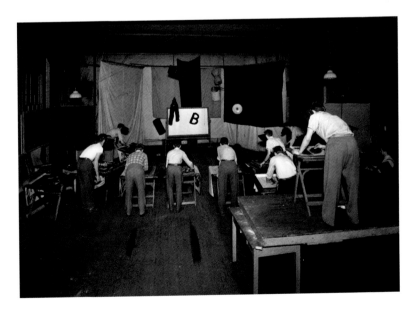

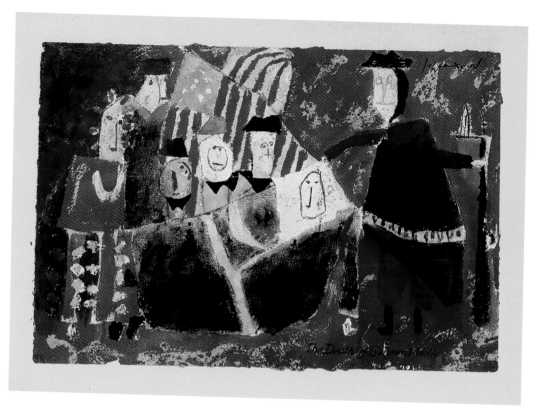

3. Roy Lichtenstein
Death of the General 1951
Watercolour on paper
40.6 × 59.7
Private Collection

Fine Arts. The following years, 1946–1950, were a period of prolific experimentation, during which he produced paintings in the style of Georges Braque, Paul Klee and Picasso, many featuring abstract figures with disproportionate limbs. Few of these works survive. His first group exhibition, in 1948, which included several paintings of this period, was at the Ten Thirty Gallery in Cleveland, Ohio. Here he met gallery assistant Isabel Wilson, whom he married the following year.

In the early 1950s Lichtenstein began to focus on distinctly American subject matter, particularly the frontier, as evident in the works *Death of Jane McCrea* 1951 and *George Washington Crossing the Delaware* 1952. The inclination to render aspects of American history was an attempt to make sense of his earlier education at the Art Students League under Reginald Marsh. He also painted several self-portraits as a medieval knight, which were shown together with the frontier paintings at John Heller Gallery, Manhattan, in 1952. The

4. Willem de Kooning
Woman III 1952–3
Oil on canvas
172.7 × 123.2
Private Collection

exhibition, although largely unrepresentative of his later career, was important in that one painting on show, *Death of the General* 1951 (fig.3), was reproduced in *Art Digest*, giving Lichtenstein the sense of a wider audience for his work.[7] Despite this minor encouragement in the press, however, sales were poor and as a result he struggled to support his young family, which by 1956 included two infant sons. Reprieve came the following year when he accepted a position as Assistant Professor of Art at the State University of New York at Oswego, where he abandoned American-themed work and embraced abstract expressionism, the style then predominant in New York. When the abstract work was shown at Condon Riley Gallery, Manhattan, in 1959, it received little attention and Lichtenstein grew increasingly frustrated.

Growing despondent in his studio, he produced a series of drawings said to be in response to Willem de Kooning's *Woman III* 1952–3 (fig.4), in which a roughly animated figure materialises from a mess of colour.[8] Only a few of these drawings remain, including

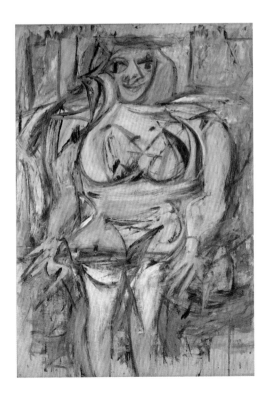

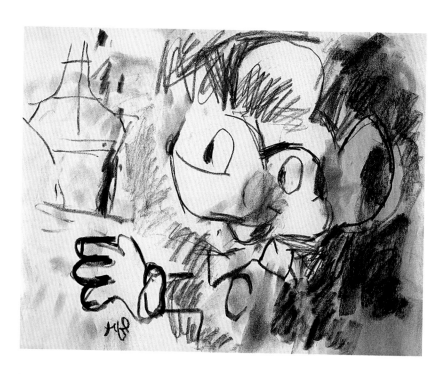

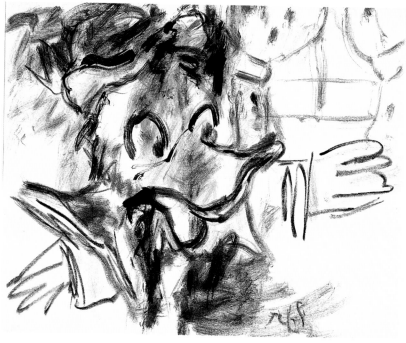

Mickey Mouse I 1958 (fig.5) and *Donald Duck* 1958 (fig.6). In *Donald Duck*, the Disney character emerges from a roughly sketched background, its hands pressing towards the sides of the paper as though attempting to break free of abstraction. The drawing reveals a tension between abstract expressionism and a more immediate, commercial style. In view of Lichtenstein's work of the preceding years, such a change in his work may appear unexpected; however the Disney characters, akin to his frontier paintings, are resolutely American. Although initially unconvinced that comic characters could stand alone as art, with the encouragement of artist and art historian Allan Kaprow, whom he met while teaching at Rutgers University, New Jersey, in 1960, Lichtenstein decided to destroy his previous work and pursue comic imagery directly. This newfound style, one that left behind years of erratic experimentation, emerged as the result of Lichtenstein attending several happenings, organised by Kaprow, which included performances by John Cage, Robert Rauschenberg and Charles Olson.[9] Kaprow believed that abstract expressionism had brought avant-garde artists to the point where 'we must become preoccupied with and even dazzled by the space of our everyday life'.[10] Thus the unbridled conviction of the happenings inspired Lichtenstein's own artistic breakthrough. He said of them: 'Happenings used more whole and more American subject matter than the Abstract Expressionists used'.[11]

Pop art?

The early 1960s was an especially innovative period for Lichtenstein. Having found an elemental source for his work in comics, he began to develop an industrial painting technique, which combined flat-print areas of solid colour with Benday dots. These are named after American artist and inventor Benjamin Day, who first generated dots when adapting pen drawings for commercial illustration in the late nineteenth century. Lichtenstein says of the process: 'I am nominally copying, but I am really restating the copied thing in other terms. In doing that, the original acquires a totally different texture. It isn't thick or thin brushstrokes, it's dots and flat colors and unyielding lines.'[12] *Look Mickey* 1961 (fig.21), sourced from an image Lichtenstein found in one of his son's children's books, from the Little Golden Books series, was the first painting to incorporate this new process.[13] The

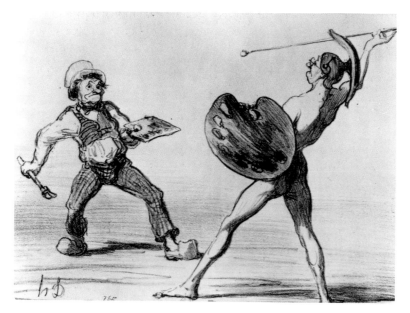

7. Honoré Daumier
The Battle of the Schools –
Idealism and Realism
Lithograph from the series
'Fantaisies', published in
Charivari, 24 April 1855
Private Collection

work shows an excited Donald Duck peering into water, having caught his own shirt in an attempt at fishing. Mickey Mouse stands beside Donald, looking on amused, hand over his mouth. The text in Donald's speech bubble reads, 'Look Mickey, I've hooked a big one!!', which Graham Bader has interpreted as reflecting Lichtenstein's aesthetic struggles over the preceding years.[14] Lichtenstein had indeed hooked a big one with this painting, having found a distinctive vision for his work, one that he was drawn to because 'it reminded me of Daumier's *Battle of the Schools*' (fig.7).[15] When asked what triggered the innovative subject matter of *Look Mickey*, Lichtenstein replied: 'Desperation. There were no spaces left', referring to the prevalence of abstract expressionism in the work of other contemporary artists.[16]

Look Mickey was drawn directly on to canvas with pencil and painted in oil, and differs only slightly from the original source; pencil marks of the initial sketch are clearly visible. The Benday dots, produced using a handmade metal screen and scrub brush, are painted equidistant in two carefully defined areas, Mickey's face and Donald's eyes. Confining the Benday dots to such small areas creates a sight line for the viewer, so that the eye travels from Mickey's face

8. Roy Lichtenstein
Step-on Can with Leg 1961
Oil on canvas
Two panels,
each 82.6 × 67.3
Fondation Louis Vuitton
pour la Création

to Donald's, and then to the water. Despite the graphic power of Disney characters in *Look Mickey,* after this work Lichtenstein largely abandoned use of children's characters and turned to newspaper advertisements and mail-order catalogues for source material. The profile for *Girl with Ball* 1961 (fig.22) was taken from a *New York Times* advertisement for a resort in Pennsylvania's Pocono Mountains. In rendering the banality of post-war advertising as vivid close-up, Lichtenstein blends the architectural acuity of Mondrian with what Clement Greenberg called 'fuliginous flatness'.[17] The result is a peculiarly modernist brand of popular art, where the girl's outline is compressed to the point where figuration almost disappears and a jigsaw of stark, colourful shapes emerges in its place.

 With an introduction from Kaprow, Lichtenstein met the Director of the Leo Castelli Gallery in New York, Ivan Karp, to whom he showed *Girl with Ball*, along with two works depicting the strange disingenuity of consumer optimism, *The Refrigerator* 1961 and *Step-on Can with Leg* 1961 (fig.8). After visiting Andy Warhol's studio at 1342 Lexington Avenue, where he was shown Warhol's consumer-goods paintings, Lichtenstein extended his method of reworking advertising

images by isolating consumer products against empty backgrounds. *Portable Radio* 1962, *Sock* 1962 and *Tire* 1962 (fig.9), of this series, are limited to black and white, making their modern sources appear antiquated, as though the consumer goods are archaic monuments, floating free, momentarily, of their market-orientation.

Lichtenstein's representation of these products came to be known as pop art, a catch-all term that does little to suggest the idiosyncratic qualities of its art. Other prominent artists of Lichtenstein's generation, including Warhol, Jasper Johns and Robert Rauschenberg, were also designated pop artists.[18] The idea was first introduced by the British art critic Lawrence Alloway in his essay 'The Arts and the Mass Media' (1958), in response to Greenberg's notion of kitsch, where he wrote in 'Avant-Garde and Kitsch' (1939), that artists had become increasingly drawn

9. Roy Lichtenstein
Tire 1962
Oil on canvas
172.7 × 142.2
The Doris and Donald Fisher Collection, San Francisco, and the Museum of Modern Art, New York

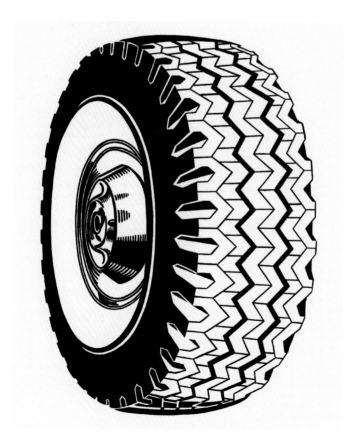

to magazine covers, illustrations, advertisements, pulp fiction, comics, tap-dancing, Hollywood movies and folk music. Alloway wrote that 'mass popular art' had become incorporated into fine art: 'Popular art, as a whole, offers imagery and plots to control the changes in the world,' where 'the new role for the fine arts is to be one of the possible forms of communication in an expanding framework that also includes the mass arts'.[19]

In and out of love
In October 1961 Lichtenstein began to receive a stipend from the Leo Castelli Gallery, meaning he could focus entirely on the production of work. At this time he tested an acrylic emulsion paint, Liquitex, before abandoning it for Magna, a paint soluble in turpentine that remained consistently flat after the application of multiple layers. He used a Magna-based varnish between coats of Magna colour, but returned to oil paint for applying Benday dots, as Magna dried too quickly. It was important for the paint to remain wet as long as possible during the lengthy production process to allow for manipulations of shape and colour.[20] He began to experiment with depictions of the archetypal young woman he had presented in *Girl with Ball*. In *The Kiss* 1961 (fig.23), a woman is kissed on the right cheek by an airline pilot, the silhouette of a plane's nose, wing, wheels and propeller blades in the top-right corner denoting the man's occupation. Benday dots on the figures' faces and arms show irregular patches where excess paint has been pushed between the metal screen. The size of the screen itself can be seen, as long rectangular blocks mark out clear white lines, making the figures' flesh appear artificial. The woman from *Girl with Ball,* advertising playful sensuality, has found a suitor in *The Kiss*, albeit a temporal one as the pilot, dressed for departure, grants a goodbye kiss.

We Rose Up Slowly 1964 (fig.37) depicts a nude young couple, eyes closed, locked in erotic elation against a backdrop of either deep water or space. The precise setting of the work is ambiguous, as suggested by the separate panel adjoined to the left, where the text, handwritten in a right-leaning slant, refers to 'swimmers in a shadowy dream'. Thus, the lust of the figures renders them beyond reality so as to become merely surface. The four ellipses in the text panel indicate the figures' breathlessness, and yet also refer to the construction of

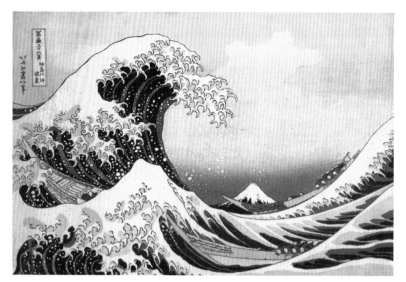

10. Katsushika Hokusai
The Great Wave at Kanagawa (from a Series of Thirty-six Views of Mount Fuji) 1823–9
Polychrome woodblock print
25.7 × 37.8
Metropolitan Museum of Art, New York

much of the image in blue and black Benday dots. Lichtenstein said of *The Kiss* and *We Rose Up Slowly*: 'I had the idea of taking a single frame out of something that implied a story.'[21]

In October 1962, Lichtenstein divorced his wife and moved into a loft in lower Manhattan with Letty Eisenhauer, a Masters student. During this period he painted *Cold Shoulder* 1963 (fig.27), *Hopeless* 1963 (fig.28) and *Oh, Jeff… I Love You, Too… But…* 1964 (fig.36), which demonstrate what critic Adam Gopnik called the 'doubleness of feeling' in Lichtenstein's works of this period, where the experience of being buoyed in love contrasts with the cold artifice of oil and Magna.[22] The women in each of the works are alone, confused and in anguish at the absence of a partner. *Drowning Girl* 1963 (fig.30), derived from a 1962 DC Comic book called *Secret Hearts*, echoes the emotion of *Hopeless*, both works showing the women's tears flooding the base of the picture plane. *Drowning Girl*, specifically, was modelled on Katsushika Hokusai's wood-block print, *The Great Wave at Kanagawa* 1823–9 (fig.10); Lichtenstein described how he 'saw [*The Great Wave*] and then pushed it a little further to transform a comic style into an art style'.[23]

to magazine covers, illustrations, advertisements, pulp fiction, comics, tap-dancing, Hollywood movies and folk music. Alloway wrote that 'mass popular art' had become incorporated into fine art: 'Popular art, as a whole, offers imagery and plots to control the changes in the world,' where 'the new role for the fine arts is to be one of the possible forms of communication in an expanding framework that also includes the mass arts'.[19]

In and out of love

In October 1961 Lichtenstein began to receive a stipend from the Leo Castelli Gallery, meaning he could focus entirely on the production of work. At this time he tested an acrylic emulsion paint, Liquitex, before abandoning it for Magna, a paint soluble in turpentine that remained consistently flat after the application of multiple layers. He used a Magna-based varnish between coats of Magna colour, but returned to oil paint for applying Benday dots, as Magna dried too quickly. It was important for the paint to remain wet as long as possible during the lengthy production process to allow for manipulations of shape and colour.[20] He began to experiment with depictions of the archetypal young woman he had presented in *Girl with Ball*. In *The Kiss* 1961 (fig.23), a woman is kissed on the right cheek by an airline pilot, the silhouette of a plane's nose, wing, wheels and propeller blades in the top-right corner denoting the man's occupation. Benday dots on the figures' faces and arms show irregular patches where excess paint has been pushed between the metal screen. The size of the screen itself can be seen, as long rectangular blocks mark out clear white lines, making the figures' flesh appear artificial. The woman from *Girl with Ball,* advertising playful sensuality, has found a suitor in *The Kiss*, albeit a temporal one as the pilot, dressed for departure, grants a goodbye kiss.

We Rose Up Slowly 1964 (fig.37) depicts a nude young couple, eyes closed, locked in erotic elation against a backdrop of either deep water or space. The precise setting of the work is ambiguous, as suggested by the separate panel adjoined to the left, where the text, handwritten in a right-leaning slant, refers to 'swimmers in a shadowy dream'. Thus, the lust of the figures renders them beyond reality so as to become merely surface. The four ellipses in the text panel indicate the figures' breathlessness, and yet also refer to the construction of

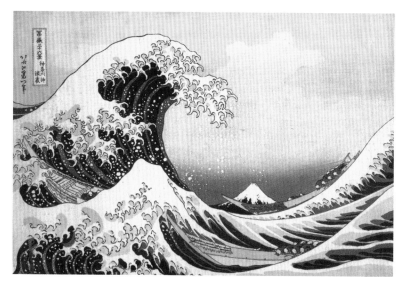

10. Katsushika Hokusai
The Great Wave at Kanagawa (from a Series of Thirty-six Views of Mount Fuji) 1823–9
Polychrome woodblock print
25.7 × 37.8
Metropolitan Museum of Art, New York

much of the image in blue and black Benday dots. Lichtenstein said of *The Kiss* and *We Rose Up Slowly*: 'I had the idea of taking a single frame out of something that implied a story.'[21]

In October 1962, Lichtenstein divorced his wife and moved into a loft in lower Manhattan with Letty Eisenhauer, a Masters student. During this period he painted *Cold Shoulder* 1963 (fig.27), *Hopeless* 1963 (fig.28) and *Oh, Jeff… I Love You, Too… But…* 1964 (fig.36), which demonstrate what critic Adam Gopnik called the 'doubleness of feeling' in Lichtenstein's works of this period, where the experience of being buoyed in love contrasts with the cold artifice of oil and Magna.[22] The women in each of the works are alone, confused and in anguish at the absence of a partner. *Drowning Girl* 1963 (fig.30), derived from a 1962 DC Comic book called *Secret Hearts*, echoes the emotion of *Hopeless*, both works showing the women's tears flooding the base of the picture plane. *Drowning Girl*, specifically, was modelled on Katsushika Hokusai's wood-block print, *The Great Wave at Kanagawa* 1823–9 (fig.10); Lichtenstein described how he 'saw [*The Great Wave*] and then pushed it a little further to transform a comic style into an art style'.[23]

11. Roy Lichtenstein
Whaam! (Study) 1963
Pencil on paper
14.9 × 30.5
Tate

War and text

Lichtenstein's use of the text balloon to convey dialogue was central to the visual vocabulary of his work, based on comic sources, in the early to mid-1960s. The balloon acts as the core focal point in a series of war paintings based on the DC Comics series *All American Men of War* (1962). In *Tex!* 1962 (fig.24), the balloon, distorted in sharp points, is white against a light-blue background of Benday dots. The text is central to the work's rhythmical unity, with the balloon's explosive shape being mirrored in the detonating plane in the upper-right corner. Both balloon and plane wreck are also broken at their edges, extending arms to different areas of the picture plane: the balloon in a lightning rod directed towards the pilot within the attacking plane, and the smoky debris of the destroyed plane that trails off into the lower-right corner. The use of an exclamation mark demonstrates the importance of the balloon text, where the addition of *!* to the *Tex* of the title visually resembles the word *Text*. Of the text balloon, Lichtenstein has said, 'it takes up a block of space in the painting, which interests me too. This becomes kind of Pop poetry in a way'.[24]

Although taken from different sources in the DC Comics series *All American Men of War*, the construction of *Whaam!* 1963 (fig.31) may be considered a reorientated, and cropped, version of *Tex!* In *Whaam!* the yellow text balloon with black lettering reads: 'I pressed

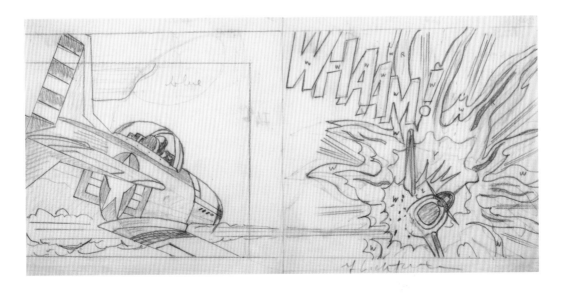

the fire control … and ahead of me rockets blazed through the sky …' The horizontal strips of yellow, black and red emanating from under the plane's right wing connect the yellow balloon and the onomatopoeic lettering ('WHAAM!') with the exploding plane in the right panel. Above the plane's three-tiered explosion (yellow, red and black, white), 'Whaam!', integrated with the image and following a jagged line, acts as an off-screen voice, as though a response by the artist to the text in the balloon.[25] The work's two panels also refer to the self-contained pictorial units of the original comic strip, with a clear line dividing the attacking plane on the left from the explosion on the right. This division is highlighted in the work's preparatory drawing (fig.11). On close inspection, the joined panels reveal a thin fissure of unprimed canvas that heightens the work's rugged materiality.

Okay Hot-Shot, Okay! 1963 (fig.32) and Torpedo … LOS! 1963 (fig.33) combine close-up portraits of fighting men with cropped text balloons. Okay Hot-Shot, Okay! also features an earlier example of the jagged line of integrated capitals ('VOOMP!') used in Whaam! Unlike in Tex! and Whaam!, where the pilot figure is enclosed in the cockpit, these works render strong emotion. However, the drama is not conveyed in the figures' irate expression, but from the text in the balloon. In both works the top circular portion of the balloons are open to the borders, allowing the off-screen voice to anchor the works' elaborate construction. Takka Takka 1962 (fig.25) and As I Opened Fire… 1964 (fig.34) also use onomatopoeic lettering, although in these works 'TAKKA' and 'BRAT!' are combined with horizontal yellow caption boxes that obscure parts of the lettering. The seemingly disinterested authorial voice in the yellow captions lacerates several letters (A, T, K). Such careful construction prioritised graphic power over simple depictions of combat: 'A minor purpose of my war paintings is to put military aggressiveness in an absurd light', Lichtenstein wrote; he also said of them that 'my work is more about our American definition of images and visual communication'.[26]

Geometry of refusal

After recreating aspects of his war paintings in sculptural form, as in Wall Explosion II 1965 (fig.44), Lichtenstein began to paint motifs that parodied or commented ironically on the artistic process associated with abstract expressionism and action painting. He had recently

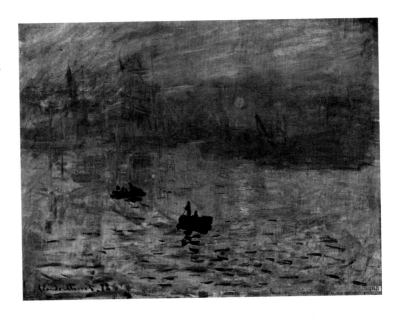

12. Claude Monet
Impression, Sunrise 1872
48 × 63
Musée Marmottan Monet,
Paris

moved into a studio in the same building as Adolph Gottlieb, at 190
Bowery Street, New York, and began producing work that discredited,
or made humorous, the apparent spontaneity of painterly gesture. In
Little Big Painting 1965 (fig.40), a cross-hatch of red and yellow swaths
of colour are pinned down by three black and white strokes on a
background of blue Benday dots. The immediate foreground signifies
spontaneous action as the strokes drip into the left- and right-hand
bottom corners. These drips recall the women's tears in *Drowning
Girl* and *Hopeless*.[27] The mechanised clarity of the thick black lines,
however, which jut sharply from the blue dots, refuse spontaneity and
reduce painterly gesture to a web of lifeless lines and dots. Of these
works, Lichtenstein has said: 'They look like a brush-stroke but they're
not one brush-stroke … They are certainly reworked when you look at
them, not spontaneous brush-strokes … they were symbolising that
art is art.'[28] *Little Big Painting* was exhibited at the Leo Castelli Gallery
in December 1965, along with *Brushstrokes* 1965 (fig.41) and *Yellow
Brushstroke I* 1965 (fig.42), which critic Lucy Lippard described as
having 'carefully depersonalized lines'.[29]

Lichtenstein produced a series of landscape paintings in the same
year as the brushstroke works. These paintings may be seen as
expanded versions of smaller fragments in previous works, such as

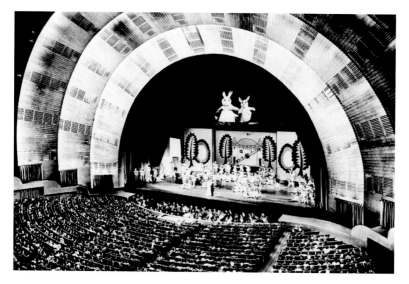

13. Interior of Radio City Music Hall, New York, on opening night, 27 December 1932 Associated Press photograph

Drowning Girl and *Hopeless*. In *Seascape* 1964 (fig.38), for example, Lichtenstein has created a horizon of light and shape by magnifying the type of lines and dots used in *Hopeless.* The upper-right portion of *Hopeless*, to the right of the eye, or the blotchy mesh of space, lines and dots below the mouth, have all been recast to create a new whole in *Seascape*. Although still figurative, *Seascape* reveals an erasure of the close-up figuration seen in *Girl with Ball*, *Hopeless* and *Drowning Girl*. In this, Lichtenstein was responding to, and reworking, impressionism: 'It's an industrial way of making Impressionism – or something like it – by a machinelike technique.'[30] Such mechanised impressionism is also employed in *Sunrise* 1965 (fig.43), where the dissection of the middle ground by the sun's rays serve to deny any possibility for subtlety, singularity or *impressions* of the real. *Sunrise* is resolutely unreal; it is sterile pattern and colour. The work echoes Claude Monet's *Impression, Sunrise* 1872 (fig.12), with both works taking the sun as a focal point and using it to manipulate the upper and lower portions of the composition. Another *Seascape* of 1964 (fig.39) exhibits a further figurative erasure, where large dots are rendered in pure colour, as though burning the trace of line and outline. As Lawrence Alloway has noted of the work, 'there is no linear scaffolding, but an allover color skin'.[31] The landscape paintings exude an overwhelming lethargy suggestive of mass-produced decorative

art of the period. Each work demonstrates a permanent deferral of emotion in favour of colour and shape, and of the defiantly unoriginal.

Purely decorative

The dialogue begun with impressionism in the landscape paintings precipitated Lichtenstein's interest in art deco the following year. If *Seascape* and *Sunrise* were examples of industrialised impressionism, the modern paintings were a hyperdelineated, and curtailed, response to art deco's interlocking geometries. *Modern Painting I* 1966 (fig.45) exhibits an inventory of sleek lines, portholes, curved paths and, beneath its midpoint, a house of triangles. The subdivided spaces recall the decorative designs and details of 1930s America, the commercial style of theatre foyers (fig.13), ocean liners and marcasite jewellery. Lichtenstein replicated fragments of geometric ornament

14. Roy Lichtenstein
Cover of *Paris Review* 1966
Screenprint on glossy
white paper
101.6 × 65.4

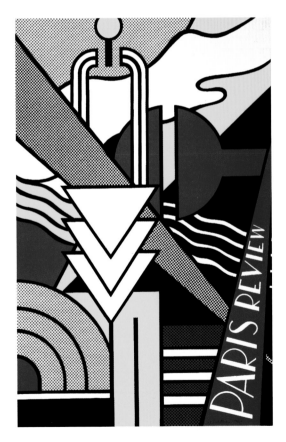

from design and architecture as a new surface for painting, where the borders of the canvas, the rectangular whole, serve to flatten, and unify, the irregular shapes. He also reworked art deco's geometrics as sculpture, in *Modern Sculpture with Glass Wave* 1967 (fig.46) and *Modern Sculpture (Maquette)* 1968 (fig.47). Lichtenstein's sources for the works included American and European design magazines and, in particular, a promotional book for Vitrolite, a company that produced opaque structural glass, called *52 Ways to Modernize Main Street with Glass*.[32] The linear symmetry of art deco had been a departure from the organic curves of its predecessor art nouveau, and had embraced cubism, neoclassicism and futurism in search of a modern style. This wilful jumbling of approaches to art and design appealed to Lichtenstein, who responded to the highfalutin claims of abstract expressionism with a similarly eclectic aesthetic. He said of art deco designers and architects: 'they felt they were much more modern than we feel we are now.'[33] To be modern, in the guise of art deco, was to be purely decorative. For Lichtenstein, though, being modern went a step further. His work *appears* as though it is purely decorative, when in fact it is impure and redecorative: its aesthetic was born of quotation and reproduction.

Before the installation of his first solo museum exhibition at the Cleveland Museum of Art in November 1966, Lichtenstein designed a cover for the literary magazine *Paris Review* (fig.14), which shared the compositional order of *Modern Painting I*, and employed art deco typography. *Modular Painting with Nine Panels* 1968 (fig.48) and *Modular Painting with Four Panels #4* 1969 (fig.49) adopt the same approach to isolating period geometrics as *Modern Painting I*, although the motifs function more as magnified close-ups of their original sources. The square box templates of the Modular paintings are organised according to what is left out, rather than the discrete patterns within. They suggest a continuation of the structure at their borders, and yet this remains invisible, akin to the manner in which Lichtenstein used the text balloons to allow for an off-screen voice in the war-comic paintings. The works' acute seriality also stems from the artist's early experimentation in Hoyt Leon Sherman's drawing classes at Ohio State, where a distinct optical impression was made when parts were seen in relation to the whole.

Quotation

In 1970 Lichtenstein moved to Southampton, New York, where he set up a studio. Away from the city, he became increasingly drawn to the act of quotation. The first monograph of his work, written by the curator Diane Waldman, was published in 1970–1, producing a visual index of his output thus far. Just as he had previously used comics, advertisements and design magazines as source material, Lichtenstein now began to use reproductions of his own work as the basis for compositions. The approach was an evolution of the process employed in the landscape paintings, where the works' compositions were organised, in part, from fragments of previous works. In *Still Life with Goldfish* 1972 (fig.51), Lichtenstein created a three-way interplay of references. For the cylindrical fish bowl, Henri Matisse's *Still Life with Goldfish* 1911 (fig.16) was the source, while the five-fingered plant in the upper left corner was reworked from the leaves in Fernand Léger's *Nature morte (un vase jaune)* 1949 (fig.15). The

15. Fernand Léger
Nature morte (un vase jaune) 1949
Oil on canvas
65 × 49
Private Collection

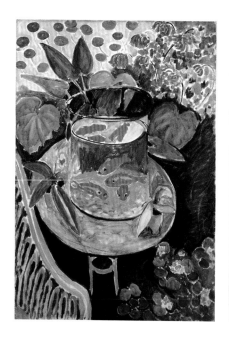

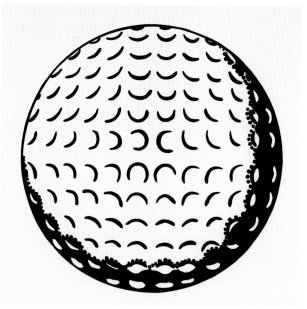

golf ball that intersects with plant and bowl in the upper right corner is Lichtenstein's *Golf Ball* 1962 (fig.17), thereby quoting the artist's work in the context of existing art historical signs. Lichtenstein's work, here, like that of Matisse and Léger, has become a dissonant reproduction. Comparatively, *Still Life with Glass and Peeled Lemon* 1972 (fig.52) combines a cubist-like merging of objects with an oblique rendering of the indelicately patterned consumer objects in Lichtenstein's *Xmas Ornament* 1963 and *Large Jewels* 1963 (fig.18). The act of quotation in these works creates a distortion of the original reference, akin to a musician re-performing a song: the sound is never the same although the referent (melody or lyric) remains. Referring to the instability of Lichtenstein's original sources in the still lifes, Alloway writes: 'The clarity of Lichtenstein's composition is like a facade in front of crumbling rooms.'[34]

During the mid- to late 1970s, having established himself in the Southampton studio, Lichtenstein underwent a period of self-reflection similar to that in the early 1960s, when *Look Mickey* was produced. In a 1973 interview he stated: 'Almost everything I'm doing, I did in the 1960s.'[35] He began a complex reworking of earlier works into the

16. Henri Matisse
Still Life with Goldfish 1911
Oil on canvas
147 × 98
Pushkin Museum,
Moscow

17. Roy Lichtenstein
Golf Ball 1962
Oil on canvas
81.3 × 81.3
Private Collection

context of a painted studio setting. *Artist's Studio "Look Mickey"* 1973 (fig.53) incorporates *Look Mickey,* along with a text balloon, as used in the comic paintings, a still life, a landscape painting and an alternate version of *Entablature #10* 1972 (fig.19). On the far left, the telephone sits upon an easel stand, resonant of the consumer goods paintings, while the stretcher frame and mirror refer to a series of works produced between 1968 and 1971, such as *Stretcher Frame with Vertical Bar* 1968 (fig.20) and *Mirror #3 (Six Panels)* 1971 (fig.50). This work, like his first monograph, was a retrospective. *Artist's Studio "The Dance"* 1974 (fig.54) also employs a studio setting, with Matisse's *The Dance* 1909 as the backdrop. The studio paintings not only create a dissolution of the categories of figurative composition (portraiture, landscape, still life) but also resist the idea of perpetual invention. Lichtenstein doesn't reinvent his work but rather quotes it, and in doing so violates the notion of original genius presented by abstract expressionism.

18. Roy Lichtenstein
Large Jewels 1963
Oil and Magna on canvas
172.7 × 91.4
Museum Ludwig, Cologne

Nudes and pneumonia

After experimenting with further quotation in a series of surrealist works, which include *Two Figures, Indian* 1979 (fig.56) and *Landscape with Figures and Rainbow* 1980 (fig.57), Lichtenstein maintained a prolific practice throughout the 1980s. The most notable work of this period is *Mural With Blue Brushstroke* 1986 (fig.58), a painting commissioned for New York's Equitable Tower, which explores the manifold colours, contradictions and processes of his oeuvre. Its formal intricacy is pastiche on an immense scale, and appears the end point of his self-quotation begun in the early 1970s with the still-life paintings. Highlighting the mural's difference to previous works, he said of the work: 'I've gotten weak in my old age and have decided to have certain subtleties, even though I hate the idea.'[36] These subtleties are the result of the sheer scale and multiple 'quotes' that make up the composition.

In the late 1980s and early 1990s Lichtenstein's status as a major American artist was acknowledged in numerous retrospectives around the world, including a touring exhibition curated by Diane Waldman at the Guggenheim Museum, New York, in 1993. He also received several honorary doctorates, most significantly from Ohio State University, his alma mater, along with the National Medal of Arts from the USA and Japan's Kyoto Prize. Lichtenstein's final works show a return to the archetypal young women explored in the 1960s. In *Nude with Red Shirt* 1995 (fig.59) and *Blue Nude* 1995 (fig.60), the women are stripped of the anxieties they demonstrated in the earlier comic paintings, appearing calm and relaxed. These works seemingly exhibit all the youthful energy, and apparent simplicity, of Lichtenstein's coming of age as an artist. However, they also contain traces of his artistic evolution in the intervening decades, with their studio settings, brushstroke-like hair, mirrors and elaborate configuration of Benday dots and diagonal lines. In looking back,

19. Roy Lichtenstein
Entablature #10 1972
Oil and Magna on canvas
66 × 365.8
Private Collection

20. Roy Lichtenstein
*Stretcher Frame with
Vertical Bar* 1968
Oil and Magna on canvas
91.4 × 121.9
Private Collection

as ever, he was searching for unknown and strange amalgams as
a means to innovate. When he died on 29 September 1997 at the
New York University Medical Center, due to complications with
pneumonia, he was mourned as an artist whose 'whole strategy of
appropriation paved the way for a generation of artists not yet born'.[37]

21
Look Mickey 1961
Oil on canvas
121.9 × 175.3
National Gallery of Art,
Washington

22
Girl With Ball 1961
Oil on canvas
153.7 × 92.7
The Museum of Modern
Art, New York

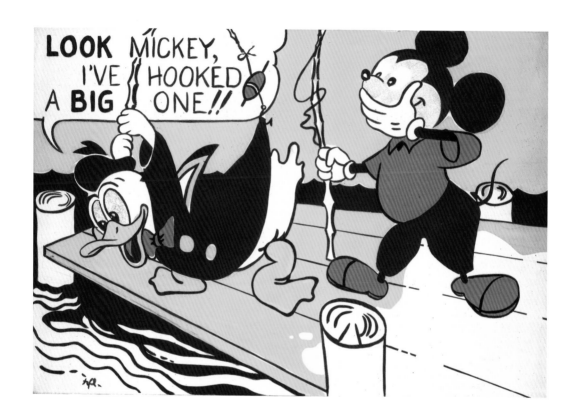

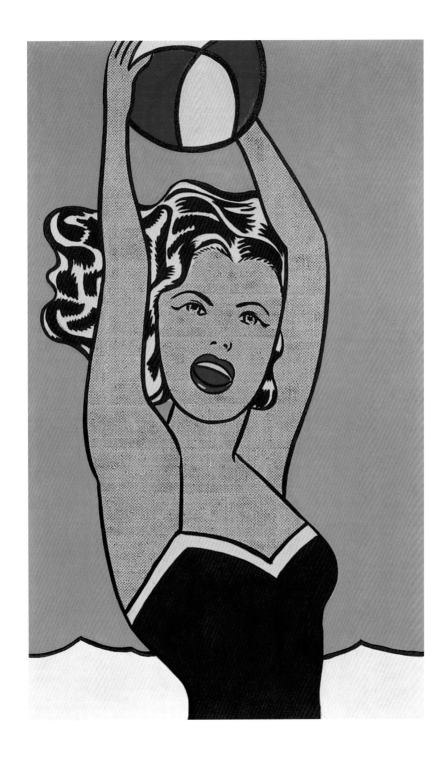

23
The Kiss 1961
Oil on canvas
203.2 × 172.7
Private Collection

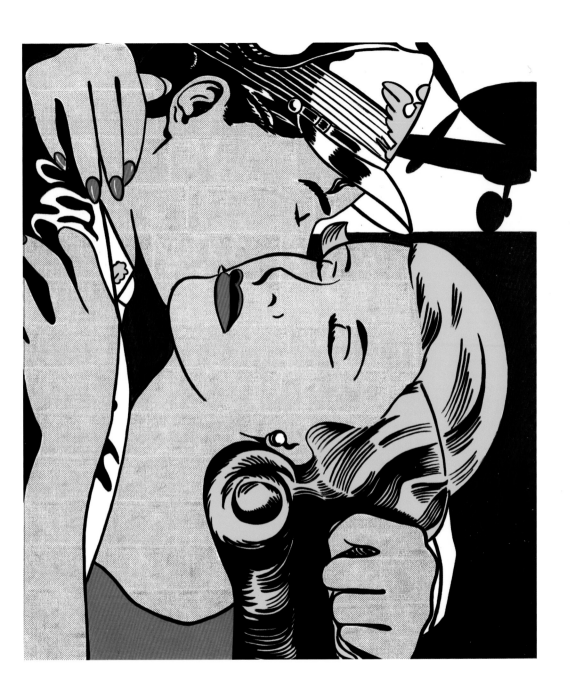

24
Tex! 1962
Oil on canvas
172.7 × 203.2
Private Collection

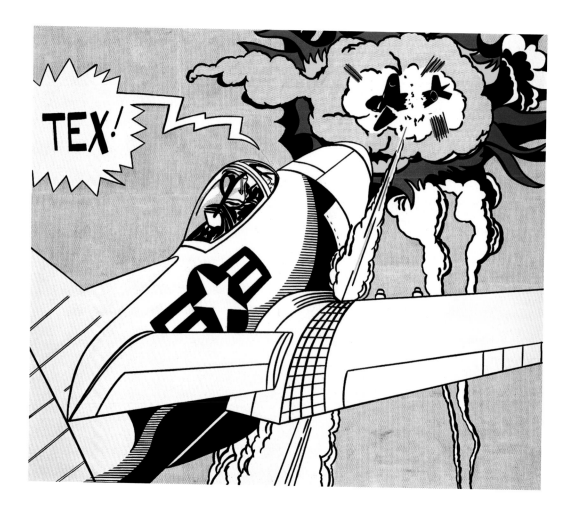

25
Takka Takka 1962
Oil and Magna on canvas
142.2 × 172.7
Museum Ludwig, Cologne

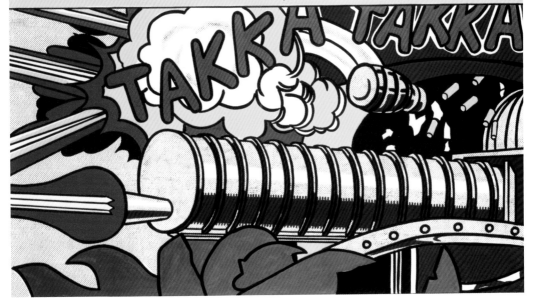

26
Femme au Chapeau 1962
Oil and Magna on canvas
172.7 × 142.2
Collection of Martin Z.
Margulies, Miami

27
Cold Shoulder 1963
Oil and Magna on canvas
174 × 121.9
Los Angeles County
Museum of Art

28
Hopeless 1963
Oil and Magna on canvas
111.8 × 111.8
Kunstmuseum Basel

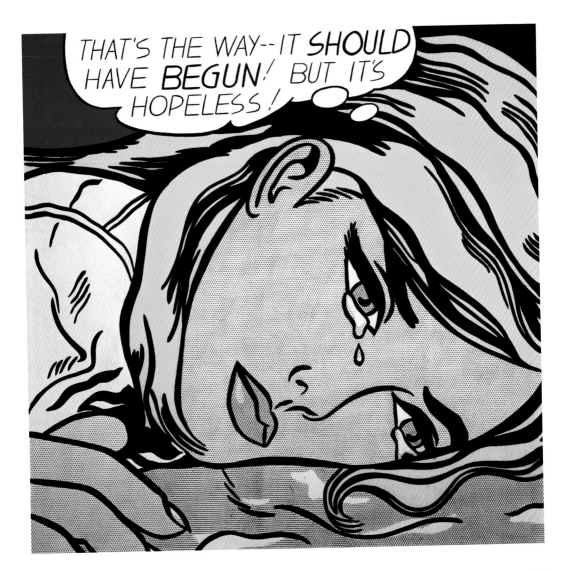

29
Mustard on White 1963
Magna on plexiglass
80 × 94 × 5.1
Tate. Lent from a private
collection

30
Drowning Girl 1963
Oil and Magna on canvas
171.6 × 169.5
The Museum of Modern
Art, New York

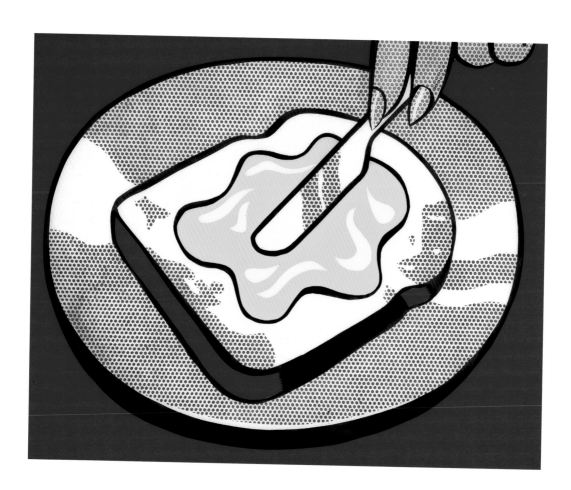

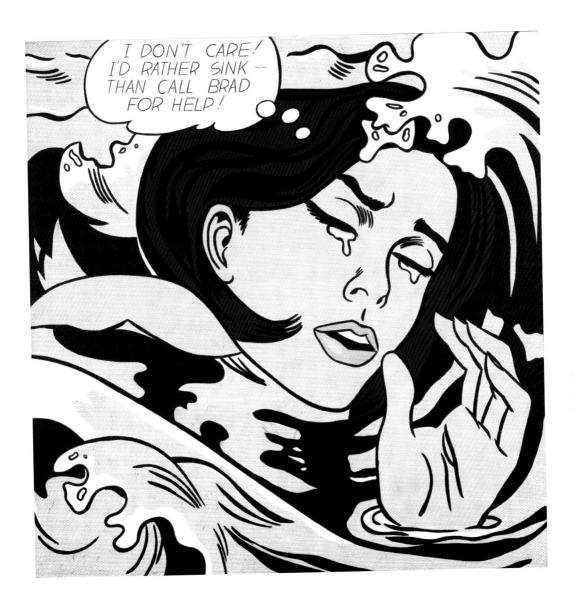

39

Whaam! 1963
Oil and Magna on canvas
Two panels,
each 172.7 × 203.2
Tate

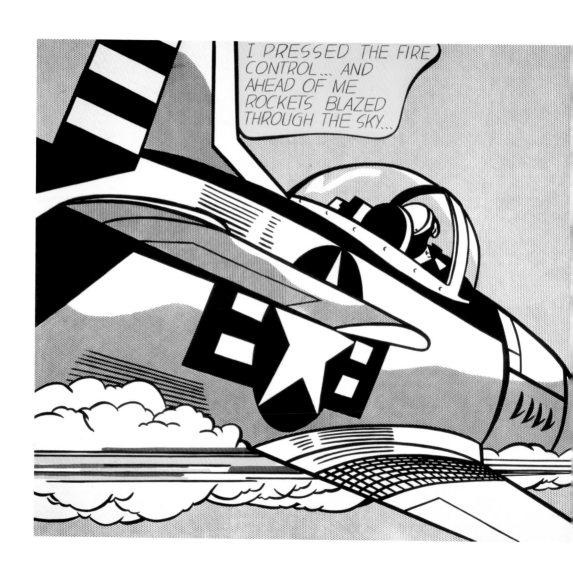

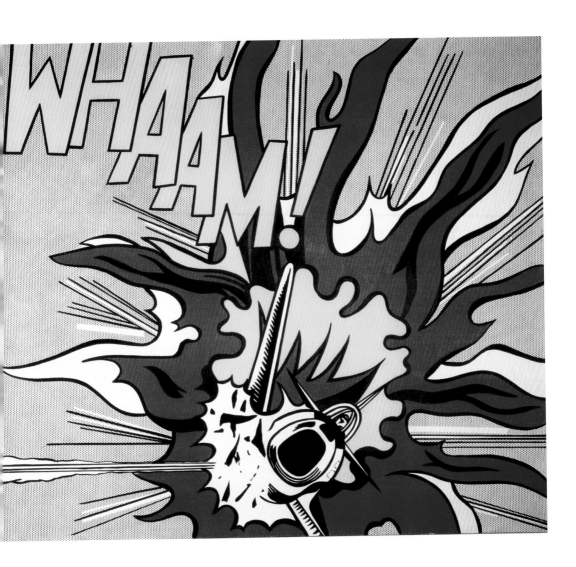

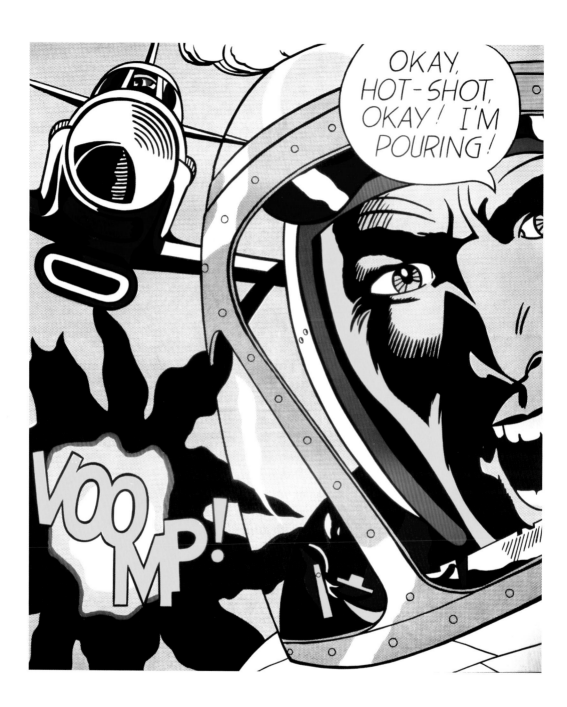

32
Okay Hot-Shot, Okay! 1963
Oil and Magna on canvas
203.2 × 172.7
Private Collection

33
Torpedo…LOS! 1963
Oil on canvas
172.7 × 203.2
Collection Simonyi

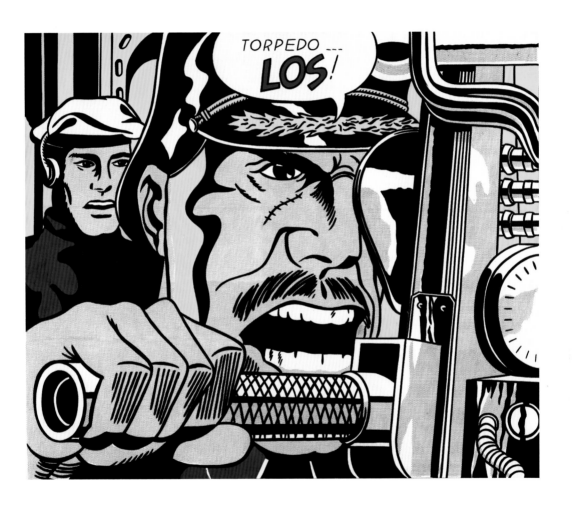

34
As I Opened Fire... 1964
Oil and Magna on canvas
Three panels,
each 172.7 × 142.2
Stedelijk Museum,
Amsterdam

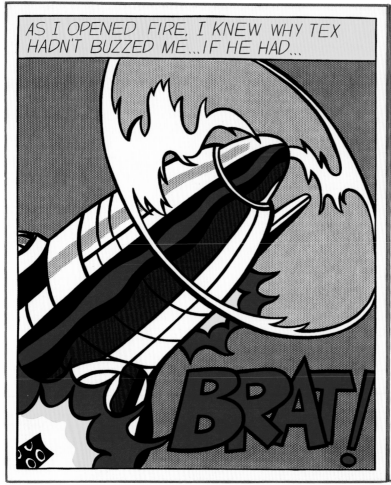
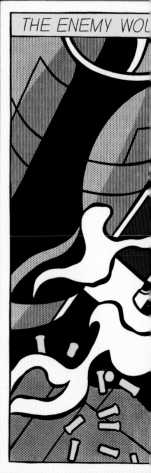

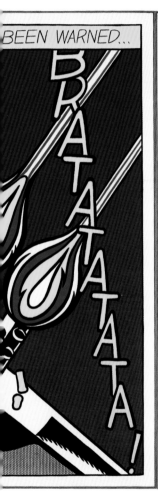

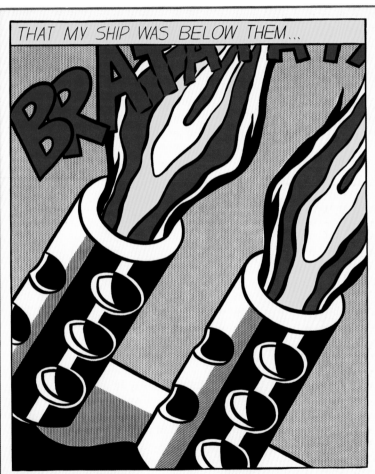

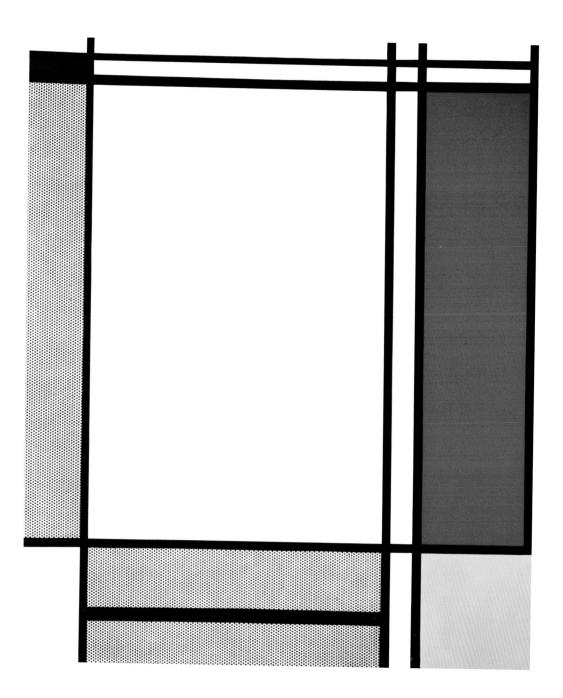

35
Non-Objective I 1964
Oil and Magna on canvas
142.9 × 121.9
The Eli and Edythe
L. Broad Collection,
Los Angeles

36
Oh, Jeff... I Love You,
Too... But... 1964
Oil and Magna on canvas
121.9 × 121.9
Collection Simonyi

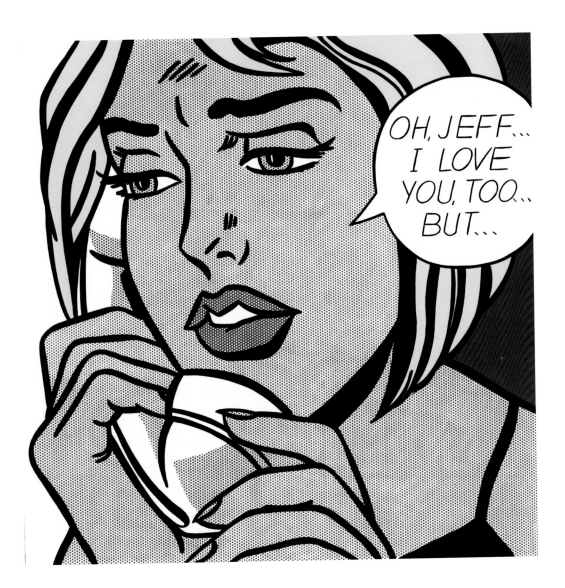

WE
ROSE UP
SLOWLY
... AS IF
WE DIDN'T
BELONG
TO THE
OUTSIDE
WORLD
ANY
LONGER
...LIKE
SWIMMERS
IN A
SHADOWY
DREAM ...
WHO
DIDN'T
NEED TO
BREATHE...

37
We Rose Up Slowly 1964
Oil and Magna on canvas
Two panels: 174.5 × 62.3;
174.5 × 234.5;
Museum für Moderne
Kunst, Frankfurt-am-Main

38
Seascape 1964
Oil on canvas
76.2 × 91.4
Private Collection

39
Seascape 1964
Oil and Magna on canvas
121.9 × 172.7
Collection Viktor and
Marianne Langen

40
Little Big Painting 1965
Oil and Magna on canvas
172.7 × 203.2
Whitney Museum of
American Art, New York

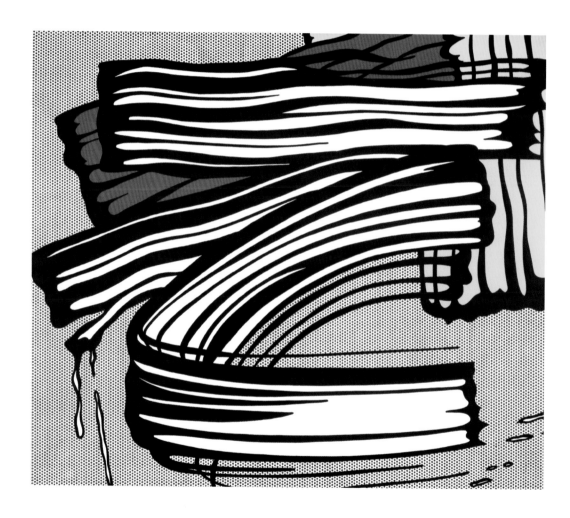

41
Brushstrokes 1965
Oil and Magna on canvas
122.5 × 122.5
Private Collection

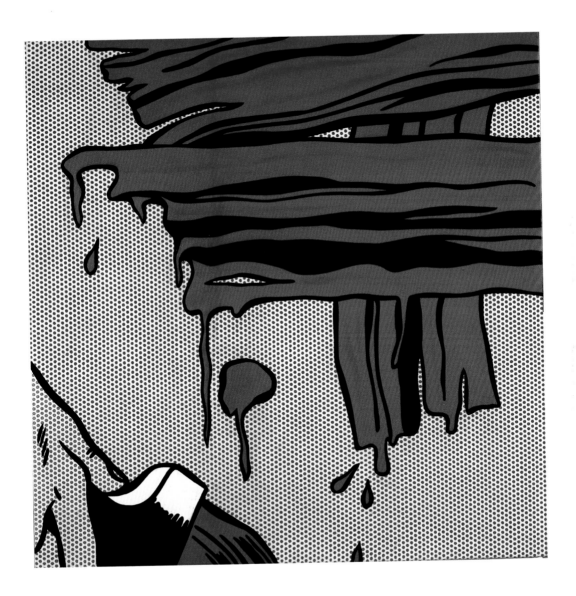

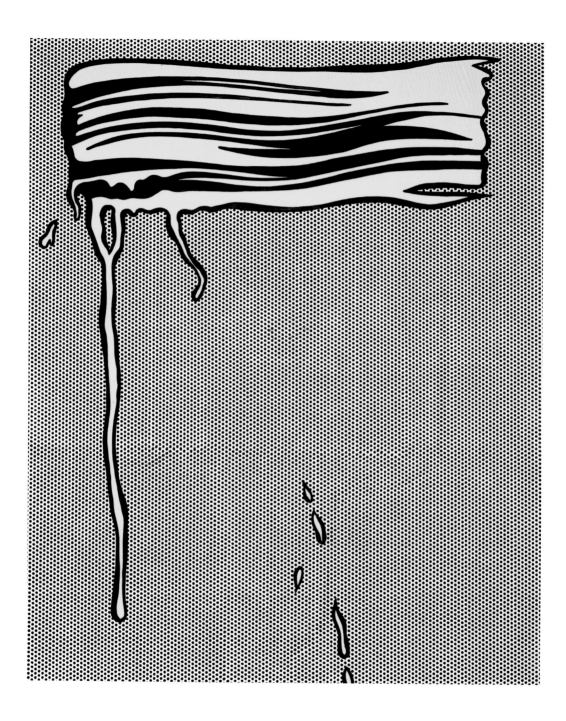

42
Yellow Brushstroke I 1965
Oil and Magna on canvas
173 × 142
Kunsthaus Zürich

43
Sunrise 1965
Oil and Magna on canvas
91.4 × 172.7
Private Collection

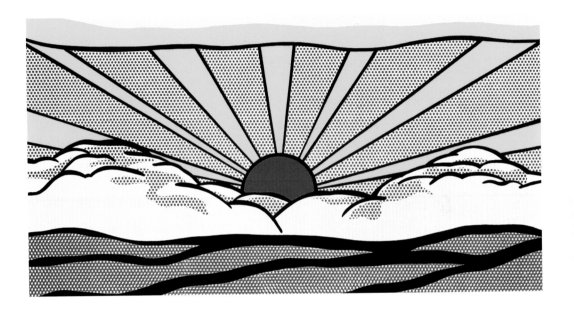

44
Wall Explosion II 1965
Porcelain enamel on steel
170.2 × 188 × 10.2
Tate

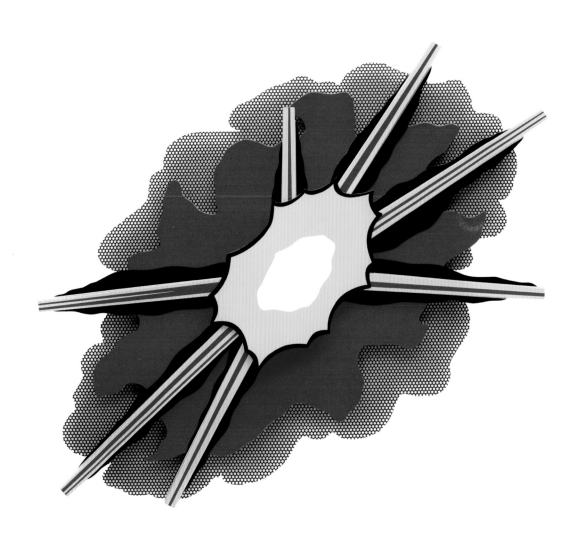

45
Modern Painting I 1966
Oil and Magna on canvas
203.2 × 172.7
Frederick R. Weisman Art
Foundation, Los Angeles

46
Modern Sculpture with
Glass Wave 1967
Brass and glass
231.8 × 73.8 × 70.1
Edition 1 of 3
The Museum of Modern
Art, New York

47
Modern Sculpture
(Maquette) c.1968
Brass
72.4 × 135.9 × 24.1
Detroit Institute of Arts

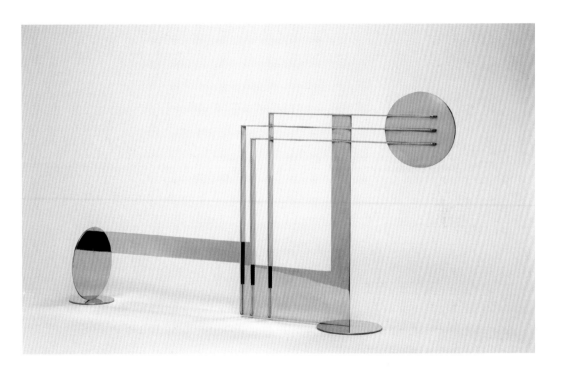

48
*Modular Painting with Nine
Panels* 1968
Oil and Magna on canvas
Overall 320 × 320
Private Collection

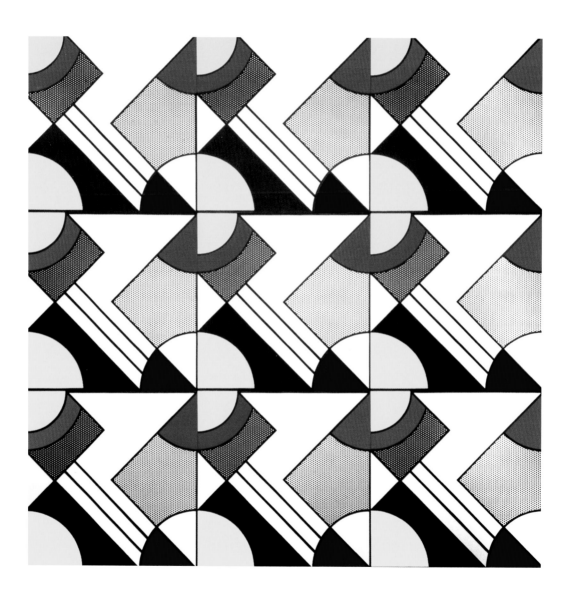

49
Modular Painting with
Four Panels #4 1969
Oil and Magna on canvas
274.3 × 274.3
Centre Pompidou, Paris

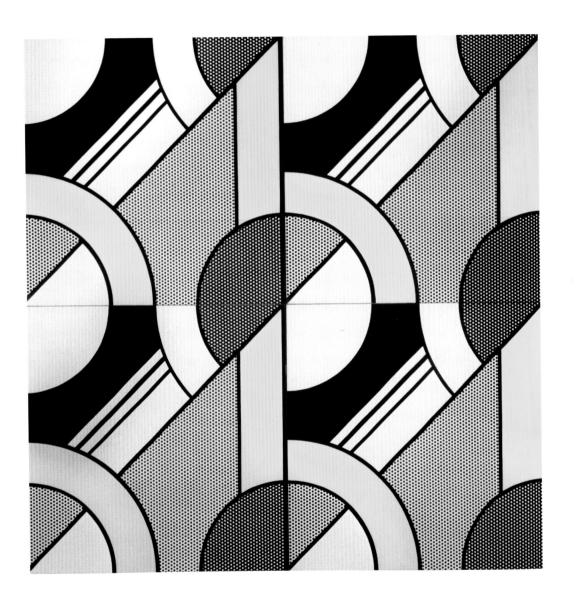

50
Mirror #3 (Six Panels) 1971
Oil and Magna on canvas
304.8 × 335.3
Art Institute of Chicago

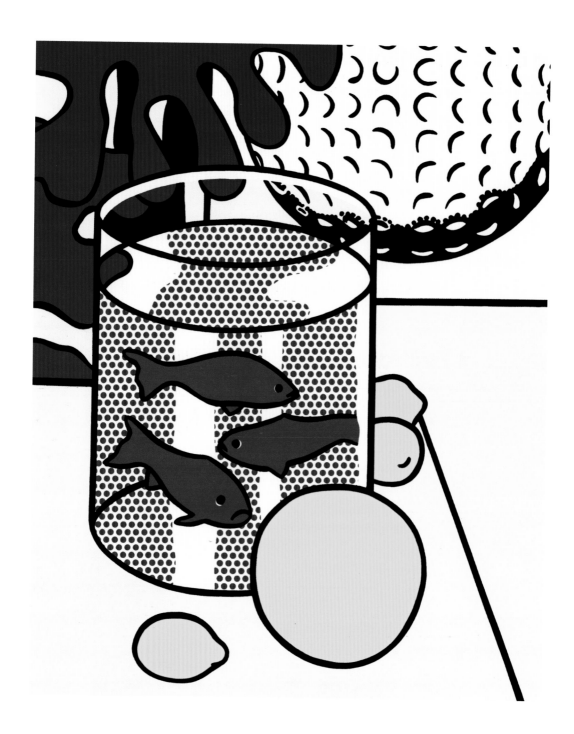

51
Still Life with Goldfish 1972
Oil and Magna on canvas
132.1 × 106.7
Private Collection

52
Still Life with Glass and
Peeled Lemon 1972
Oil and Magna on canvas
106.7 × 121.9
The Helman Collection

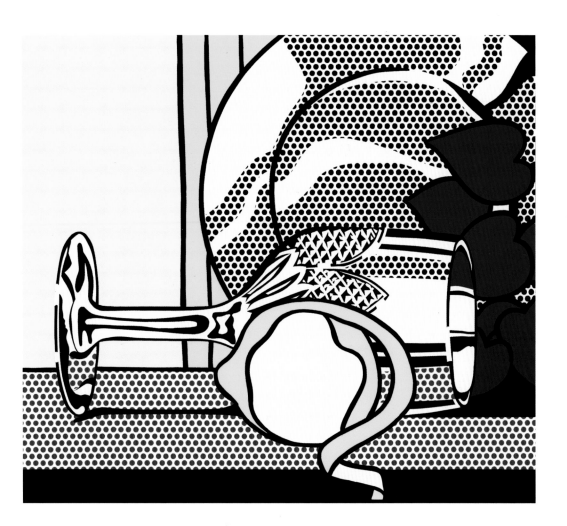

53
Artist's Studio
"Look Mickey" 1973
Oil, Magna and sand
with aluminium powder
on canvas
243.8 × 325.1
Walker Art Center,
Minneapolis

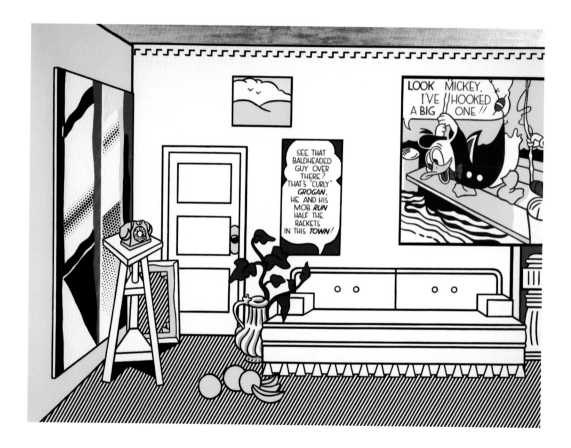

54
Artist's Studio
"The Dance" 1974
Oil and Magna on canvas
243.8 × 325.5
The Museum of Modern
Art, New York

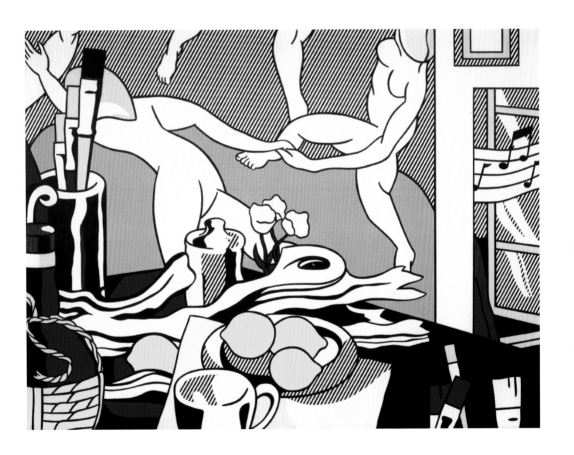

55
Frolic 1977
Oil and Magna on canvas
203.2 × 167.6
Private Collection

56
Two Figures, Indian 1979
Oil and Magna on canvas
177.8 × 218.4
Private Collection

57
*Landscape with Figures
and Rainbow* 1980
Oil and Magna on canvas
213.4 × 304.8
Museum Ludwig, Cologne

58
*Mural with Blue
Brushstroke* 1986
Oil and Magna on canvas
2072.6 × 975.4
The AXA Equitable Center,
New York

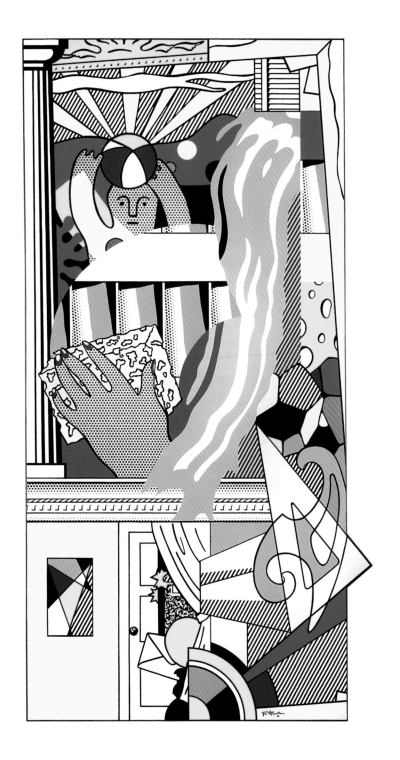

59
Nude with Red Shirt 1995
Oil and Magna on canvas
198.1 × 167.6
Private Collection

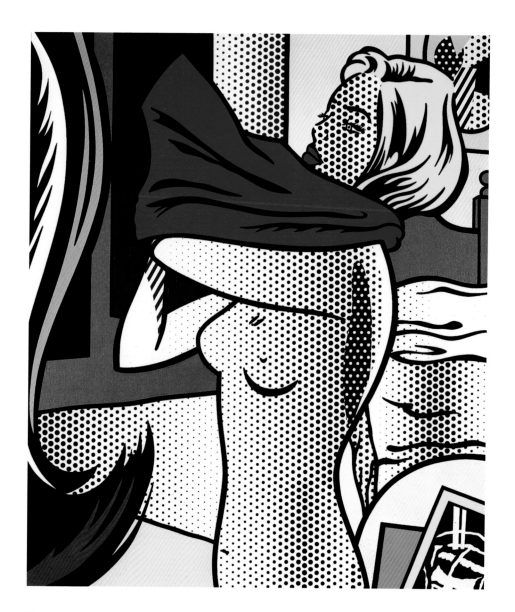

60
Blue Nude 1995
Oil and Magna on canvas
205.7 × 152.4
Aphrodite Arts Limited

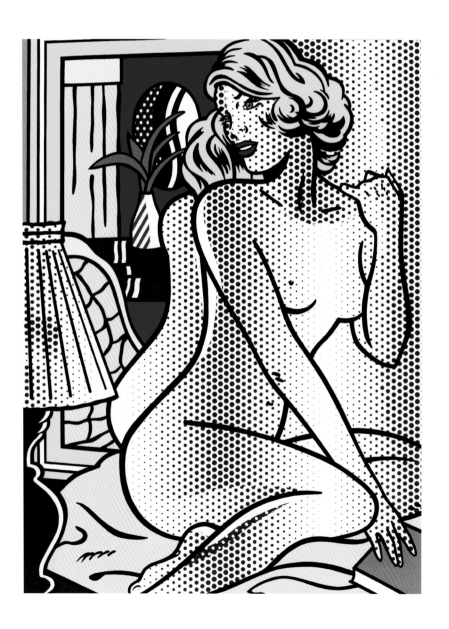

Notes

1. Dorothy Seiberling, 'Is He the Worst Artist in the U.S.?', *Life*, 31 January 1964, vol.56, no.5, p.79.

2. Lawrence Alloway, *Roy Lichtenstein*, Modern Masters, vol.1, New York and London 1983, p.9.

3. Alan Solomon, 'Conversation with Lichtenstein', in John Coplans (ed.), *Roy Lichtenstein*, New York 1972, p.66.

4. Lichtenstein interviewed by Gene R. Swenson, 'What is Pop Art? Answers from Eight Painters, Part I,' *Art News*, vol.62, no.7, 1963, p.25.

5. Janis Hendrickson, *Roy Lichtenstein*, Cologne 1988, p.10.

6. Ibid.

7. James Fitzsimmons, 'Roy Lichtenstein', *Art Digest,* vol.27, no.7, 1 January 1952, p.20.

8. Three decades later Lichtenstein returned to de Kooning's *Woman III* and painted a work of the same name, *Woman III* 1982.

9. For more information on the connection between pop art and happenings, see Allan Kaprow, 'The Happenings Are Dead: Long Live the Happenings!' in *Essays on the Blurring of Art and Life*, Berkeley 1993, pp.59–65.

Also see Jürgen Weber, *Pop Art: Happenings and Neue Realisten*, Munich 1970.

10. Allan Kaprow, 'The Legacy of Jackson Pollock', *Art News*, vol.57, 1958, p.56.

11. Bruce Glaser, 'Oldenburg, Lichtenstein, Warhol: A Discussion', in Coplans 1972, p.57.

12. Lichtenstein, interviewed by Lawrence Alloway, February 1983, in Alloway 1983, p.106.

13. *Walt Disney's Donald Duck, Lost and Found*, written by Carl Buettner, with pictures by Bob Grant and Bob Totten, Little Golden Books series, New York 1960.

14. Graham Bader, 'Donald's Numbness', *Oxford Art Journal*, vol.29, no.1, 2006, pp.95–113, especially pp.95–7.

15. Bradford R. Collins, 'Modern Romance: Lichtenstein's Comic Book Paintings', *American Art*, vol.17, no.2, 2003, pp.60–85, especially p.65.

16. John Coplans, 'An Interview with Roy Lichtenstein', *Artforum*, vol.2, no.4, 1963, p.31.

17. Clement Greenberg, 'The Present Prospects of American Painting and Sculpture', *Horizon*, no.93–4, 1947, p.26.

18. For an introduction to pop art, see David McCarthy, *Pop Art*, London 2002. For a more detailed discussion, see Sylvia Harrison, *Pop Art and the Origins of Postmodernism*, Cambridge 2001.

19. Lawrence Alloway, 'The Arts and the Mass Media', *Architectural Design*, vol.28, no.2, 1958, pp.84–5.

20. Alloway, 'Notes on Technique', in Alloway 1983, pp.109–11.

21. Lichtenstein, interviewed by Bradford R. Collins, quoted in 'Modern Romance: Lichtenstein's Comic Book Paintings', *American Art*, vol.17, no.2, 2003, pp.60–85, especially p.70.

22. Adam Gopnik, 'The Wise Innocent', *New Yorker*, 8 November 1993, p.120.

23. Lichtenstein, in John Coplans, 'Talking with Roy Lichtenstein', *Artforum*, vol.5, no.9, May 1967, pp.34–9 (p.34).

24. Lichtenstein, radio interview with David Sylvester in New York, broadcast January 1966, BBC Third Programme.

25. Albert Boime, 'Roy Lichtenstein and the Comic Strip', *Art Journal*, vol.28, no.2, 1968–9, pp.155–9, especially pp.156–7.

26. Quoted in Janis Hendrickson, *Roy Lichtenstein*, Cologne 1988, p.29.

27. William Berkson, 'Roy Lichtenstein,' *Arts*, no.40, 1966, p.54.

28. Lichtenstein, radio interview with Sylvester 1966.

29. Lucy Lippard, *Pop Art*, London 1966, p.125.

30. Quoted in Alloway 1983, p.53.

31. Ibid.

32. See ibid., p.37.

33. Lichtenstein, quoted in Alloway, 'Roy Lichtenstein's Period Style: From the 30s to the 60s and Back', in Coplans 1972, p.145.

34. Alloway 1983, p.84.

35. Michael Brenson, 'The Changing World of Roy Lichtenstein', *New York Times,* 10 August 1982, p.9.

36. Lichtenstein, quoted in Calvin Tomkins and Bob Adelman, *Roy Lichtenstein: Mural with Blue Brushstroke*, New York 1988, p.12.

37. Michael Kimmelman, 'Roy Lichtenstein, Pop Master, Dies at 73', *New York Times*, 30 September 1997.

Index